the wit and whimsy of
Mary Engelbreit

the wit and whimsy of
Mary Engelbreit

**Andrews McMeel
Publishing**

Kansas City

ISBN: 0-8362-2775-1

Library of Congress Catalog Card Number: 96-86598

Design by Stephanie Raaf

ATTENTION: SCHOOLS AND BUSINESSES
Andrews McMeel books are available at quantity discounts with bulk
purchase for educational, business, or sales promotional use.
For information, please write to: Special Sales Department,
Andrews McMeel Publishing, 4520 Main Street, Kansas City, Missouri 64111.

Contents

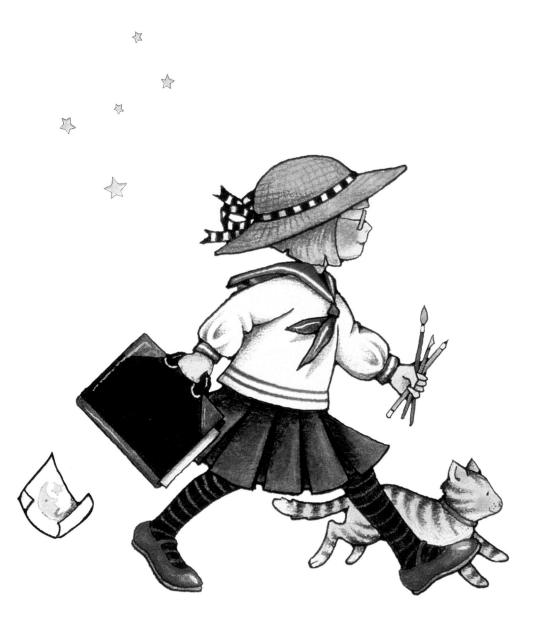

6

Introduction

It's been so much fun working on this book! The closest thing that I could compare it to is sitting down with a photo album and reminiscing; in this case, the memories take me back over the last two decades of my life.

One of the reasons I enjoy looking at my past work is because it triggers memories. People often ask me how I get my ideas. The truth is I don't have to "get" them; they come to me. Sometimes they come from life's tender moments, like watching a baby take his first steps, or reading a bedtime story. I think people imagine that I set a scene and then draw it, like an artist in a studio with a still-life of fruit. No, the scenes are all in my mind's eye. Someone (a very young someone) once asked if I had angels or fairies helping me when I draw. I laughed, but, upon second thought, I was flattered that young people see a magical side of my artwork.

Other times, my mood determines what I draw that day. If I'm frustrated by something, it's often very therapeutic to express it in my illustrations. Though I'll admit that I draw my share of idealized scenes—a happy family sitting peacefully together around the hearth or brothers with their arms slung over each others' shoulders—I also try to acknowledge life's realities, that some days go more smoothly than others, that you can't have everything you want all of the time. That's where the ideas for cards like those showing a baby with a bowl of food dumped over his head or a harried mother after a birthday party are born. People respond to these cards, too, because we've all been there.

Another pleasurable benefit of my work is knowing that it made someone happy. Sometimes, it's fun to imagine the places where my illustrations will turn up. The moment I put my marker

and pencil down and declare an illustration done, it's only begin-
ning its life. Perhaps it will end up in the hands of a mother-to-be, or
a veteran mom on Mother's Day. I like to think about the miles of
smiles a Father's Day card might elicit. And, it is my hope, my illus-
trations have provided needed moments of comic relief—like my
card that shows a beleaguered Mom with her "alien" sons.

I've received so many charming letters over the years from
people who have taken a sentiment expressed in the card—for
instance "Don't Look Back"—and run with it. It's satisfying to know
that you've made a positive impact. Sometimes my drawings go out
into the world and take on lives of their own—kind of like children.
A little girl wrote me to say she had been proudly wearing a "Queen
of Everything" t-shirt to put the boys in her class in their place.
Another woman dropped me a note saying that she used my

"Oh No" card as inspiration for the design of her thirtieth birthday cake. What a fun way of dealing with what is a "crisis" for some. One day I opened an envelope to find snapshots of an office that looked like one of my cards come to life. A woman had re-created a decorative border from one of my illustrations and used it to perk up the walls. She says it makes her clients feel more comfortable.

I knew from a very young age that I wanted to be an artist, because as an artist I'd never have to leave the magic or the mystery of childhood behind. When I get letters from real children saying they connected with my work in some way, it confirms that I haven't left it behind. Sometimes kids ask how they could get started on an artistic career, and that's especially gratifying, because you know you've made a difference in their lives. That is what motivates me to get back to the drawing board again and again—even when it's

110 degrees in the shade on a St. Louis July afternoon and eight Christmas cards are due.

For all those people who keep asking for book collections of my art, I hope you enjoy this small volume. So please keep those cards and letters coming, and I'll do the same.

Mary

chapter 1

Sometimes Less Is More

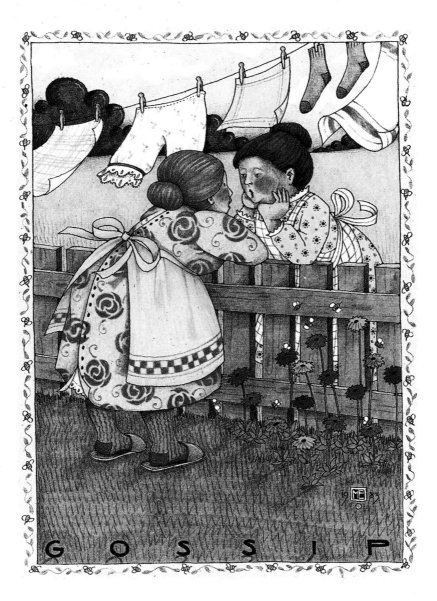

GOSSIP

14

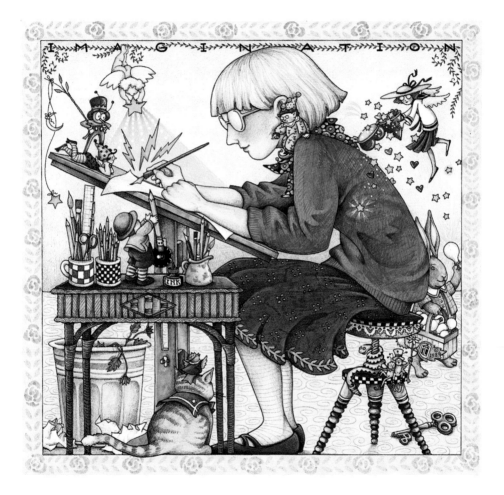

15

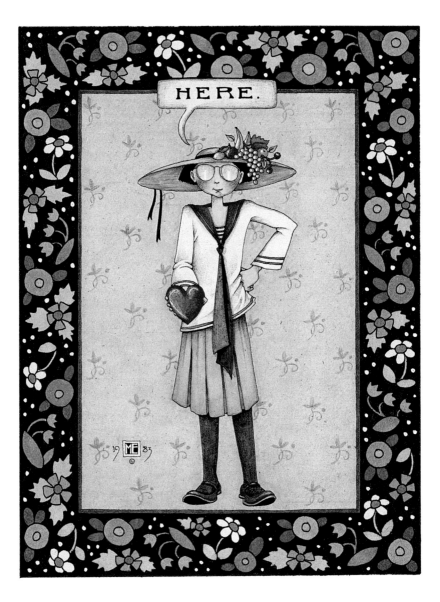

16

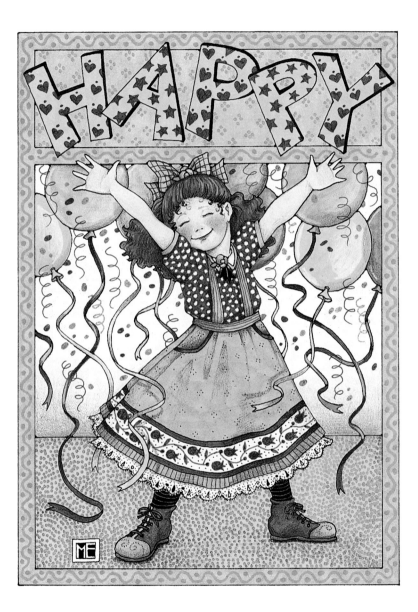

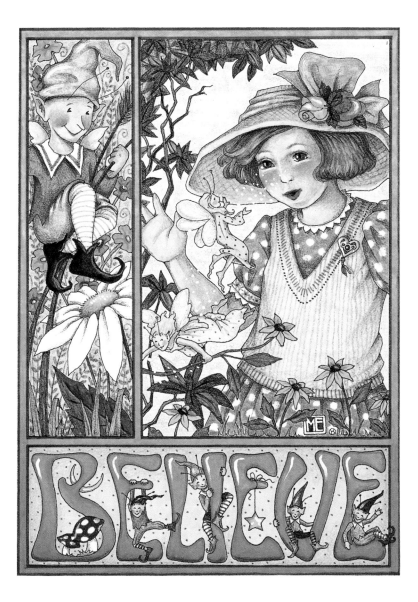

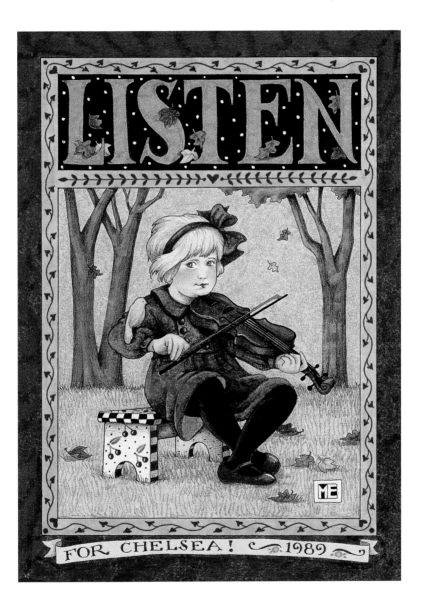

19

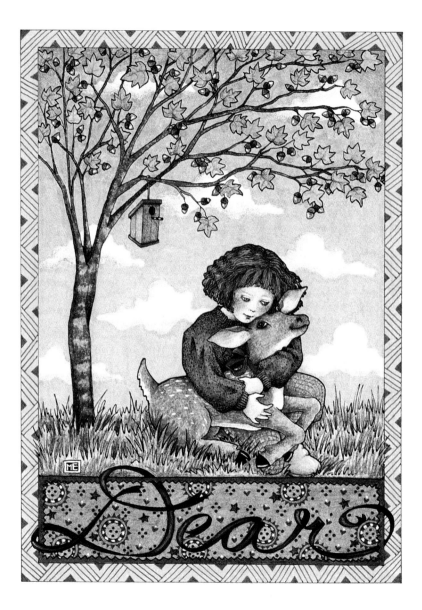

20

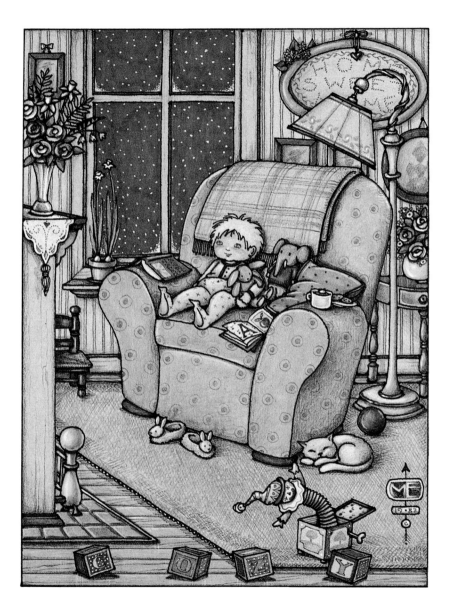

21

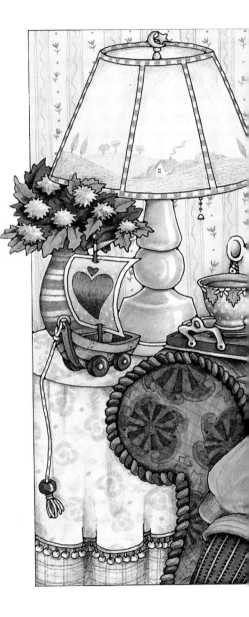

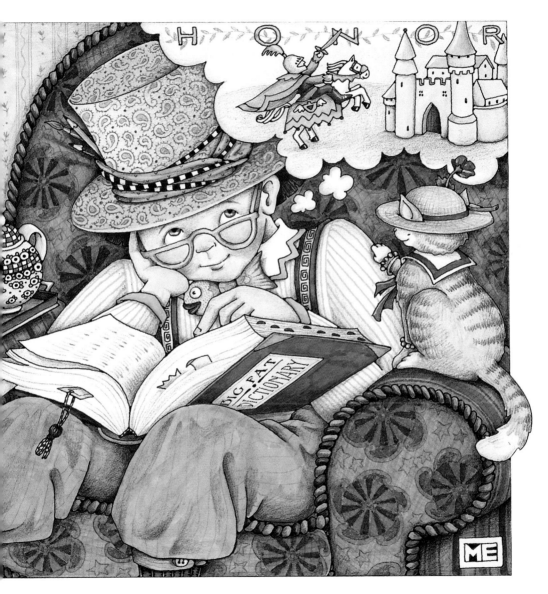

23

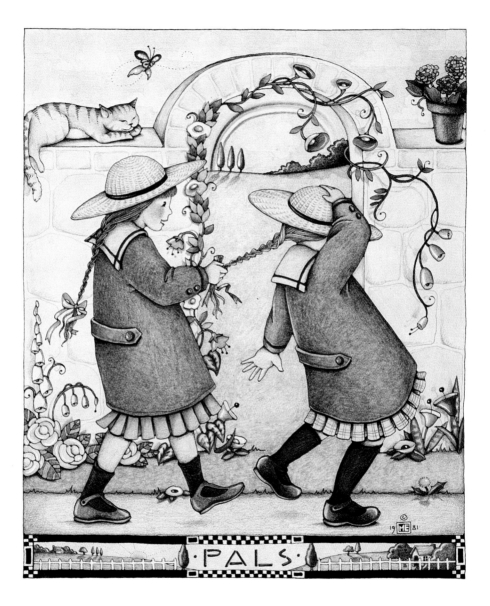

· PALS ·

24

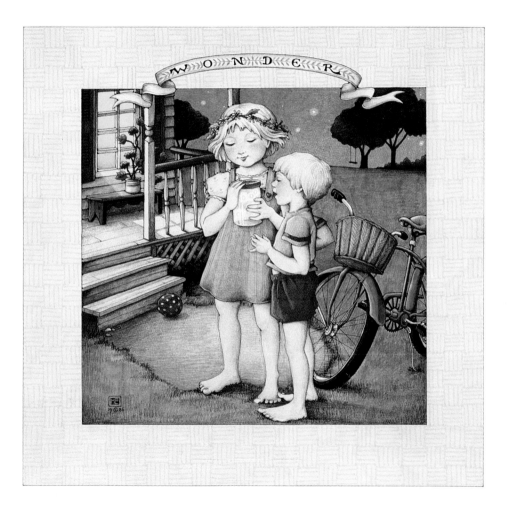

25

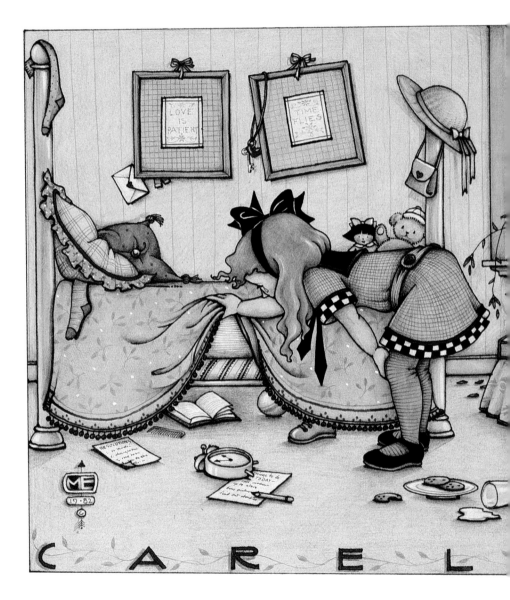

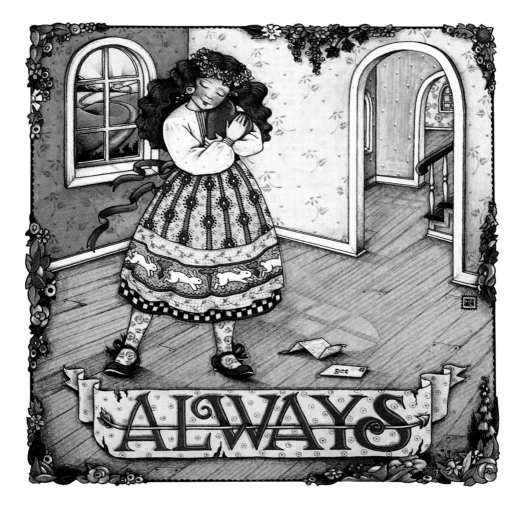

ALWAYS

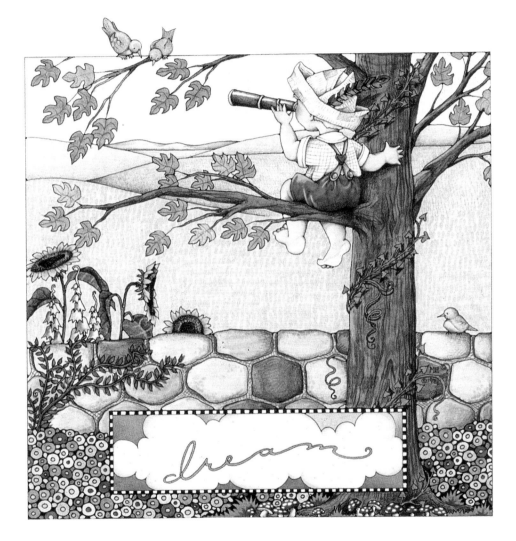

dream

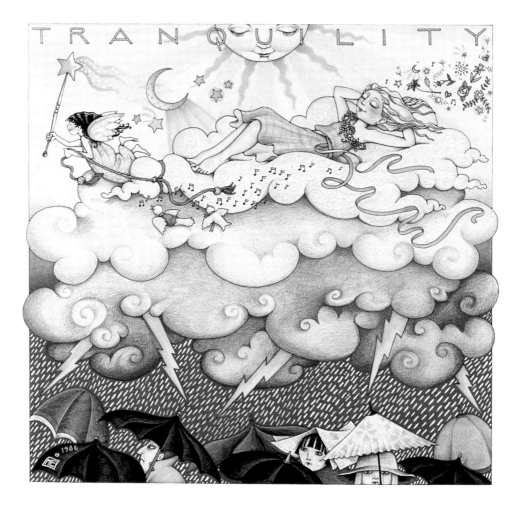

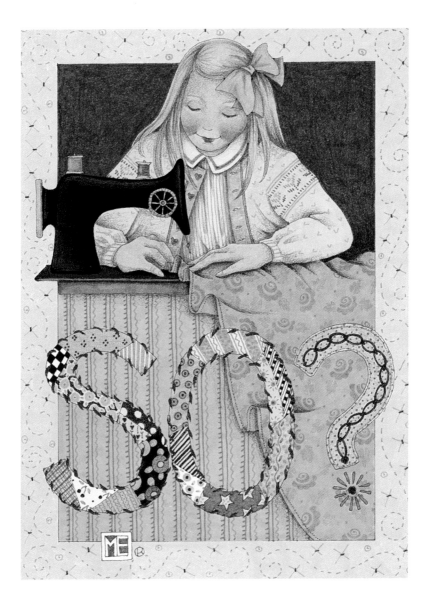

31

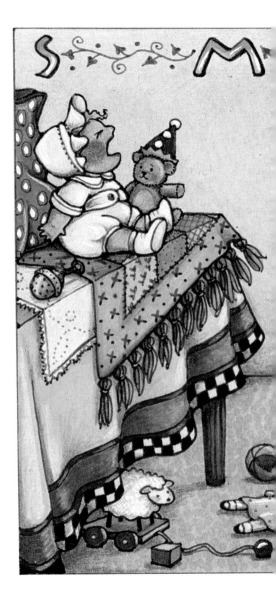

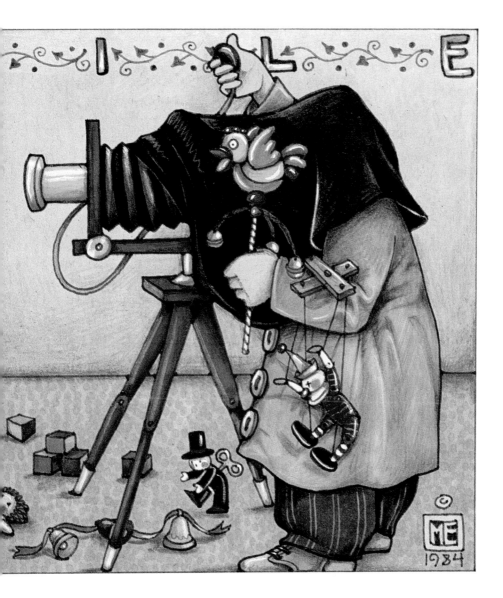

33

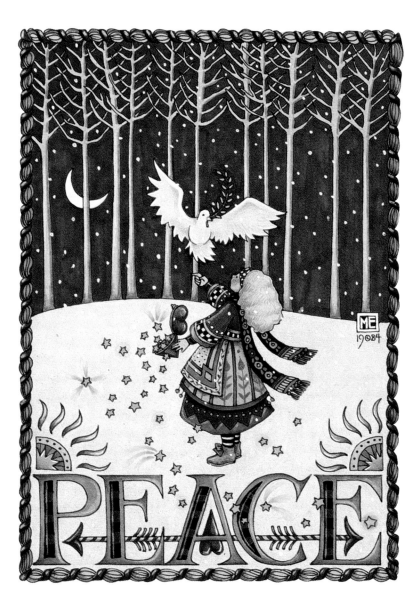

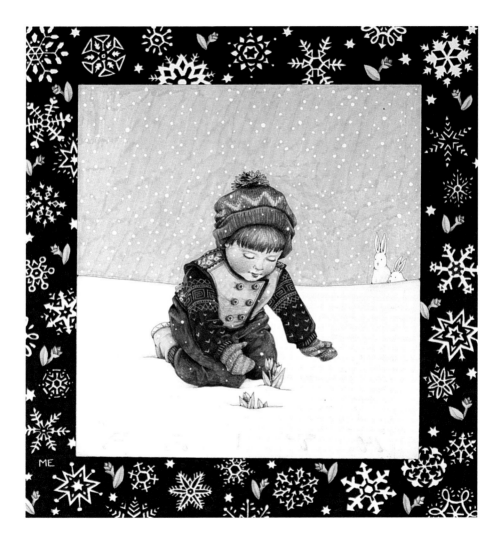

chapter 2
Seize the Moment

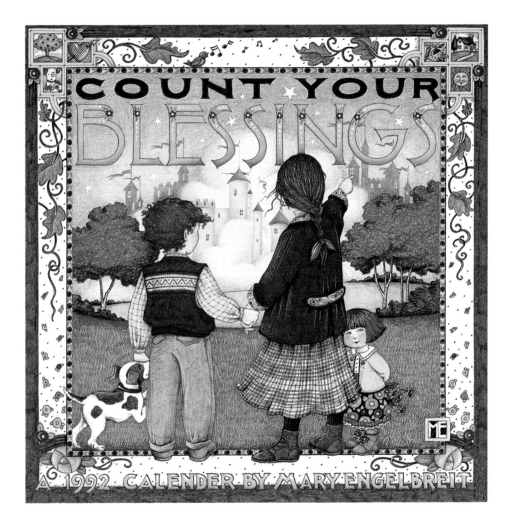

COUNT YOUR BLESSINGS

A 1992 CALENDER BY MARY ENGELBREIT

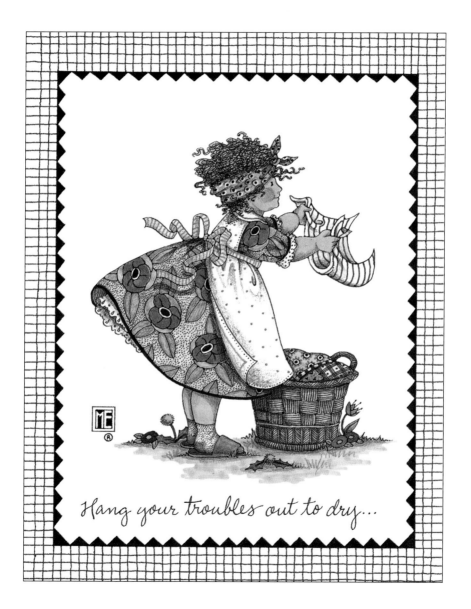

Hang your troubles out to dry...

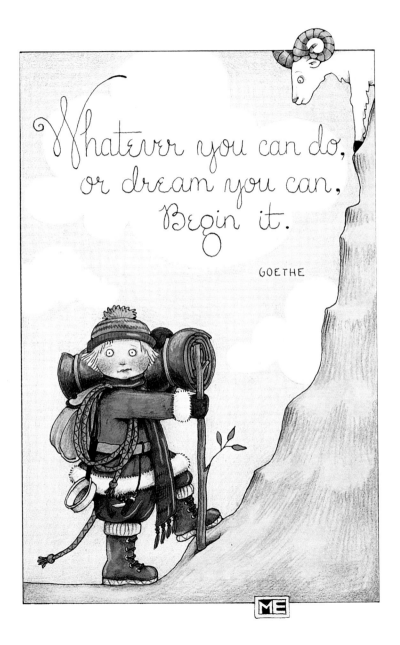

Whatever you can do,
or dream you can,
Begin it.

GOETHE

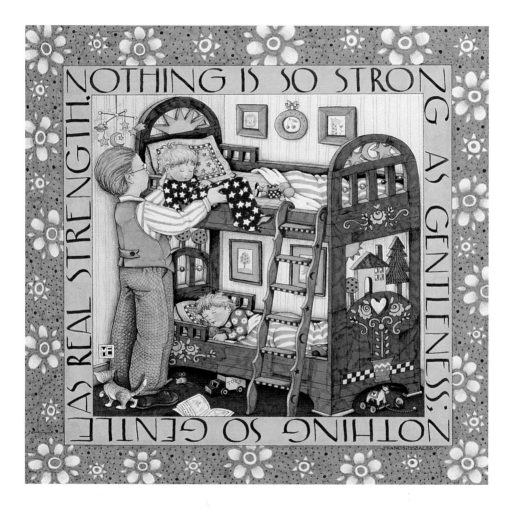

NOTHING IS SO STRONG AS REAL STRENGTH. NOTHING SO GENTLE, NOTHING SO GENTLE AS GENTLENESS.

FRANCIS DE SALES

41

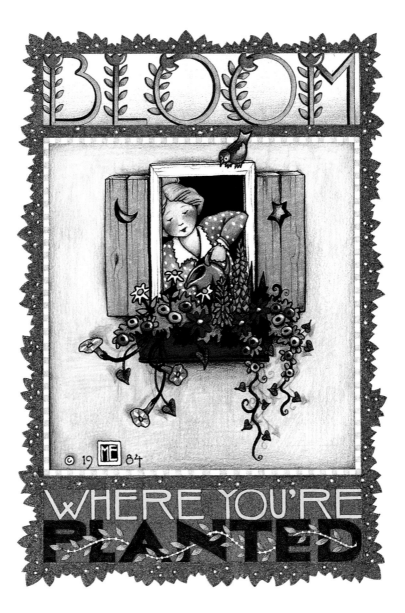

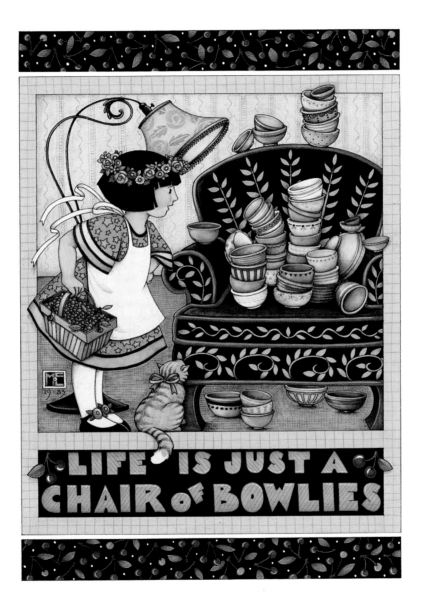

LIFE IS JUST A CHAIR OF BOWLIES

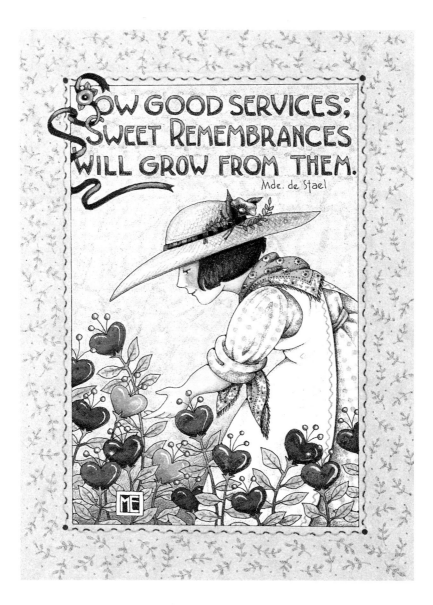

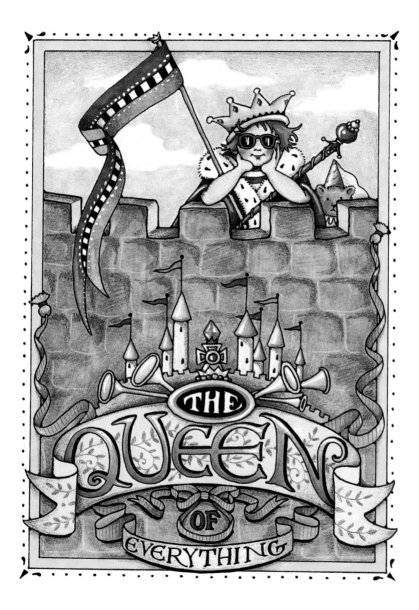

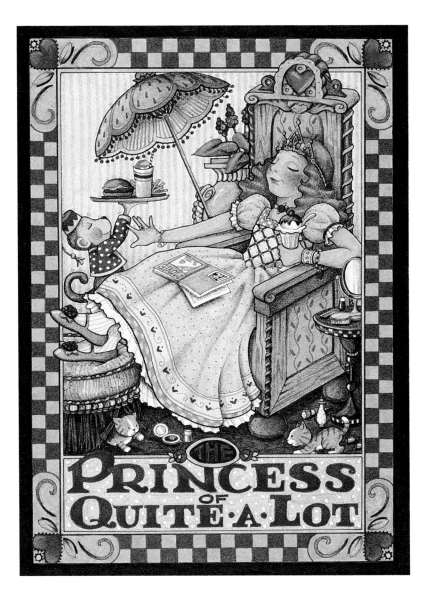

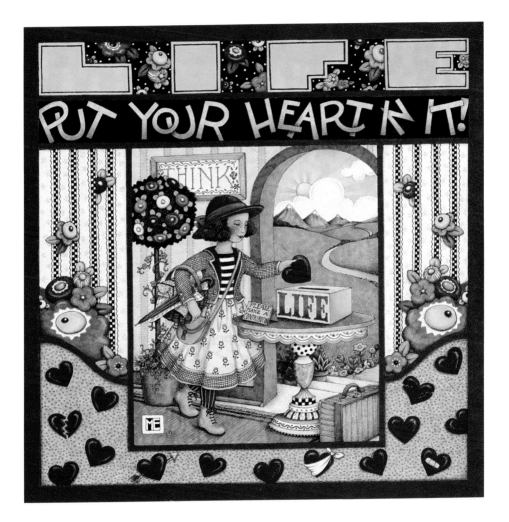

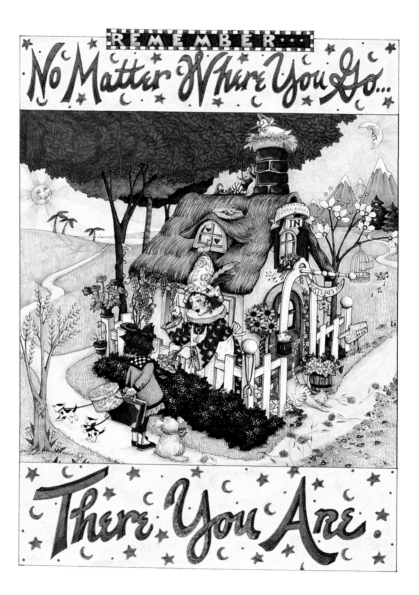

48

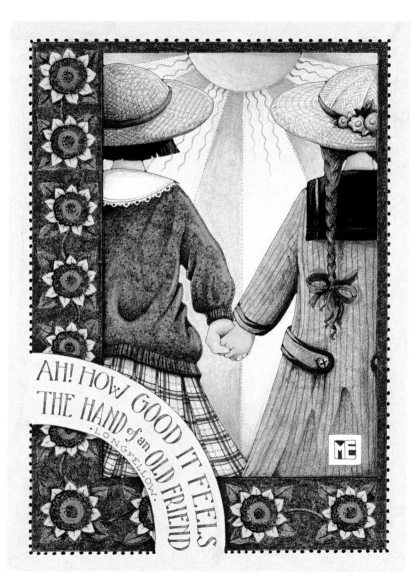

AH! HOW GOOD IT FEELS THE HAND of an OLD FRIEND
·LONGFELLOW·

49

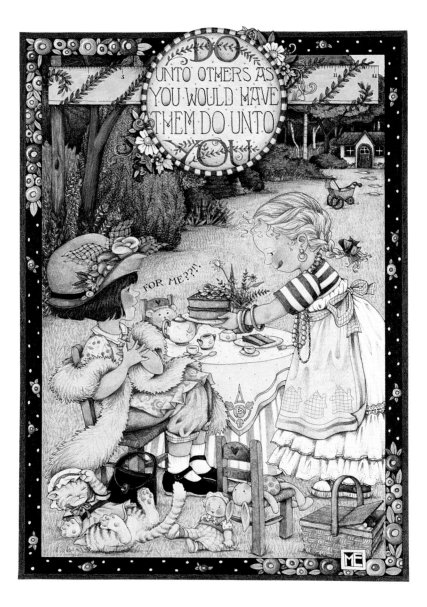

DO UNTO OTHERS AS YOU WOULD HAVE THEM DO UNTO YOU

FOR ME??!!

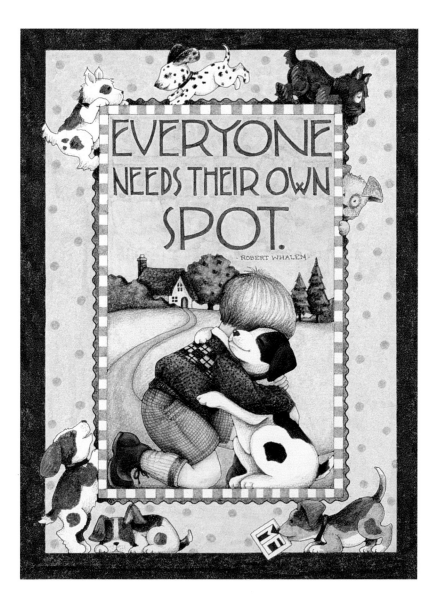

EVERYONE NEEDS THEIR OWN SPOT.

· ROBERT WHALEN ·

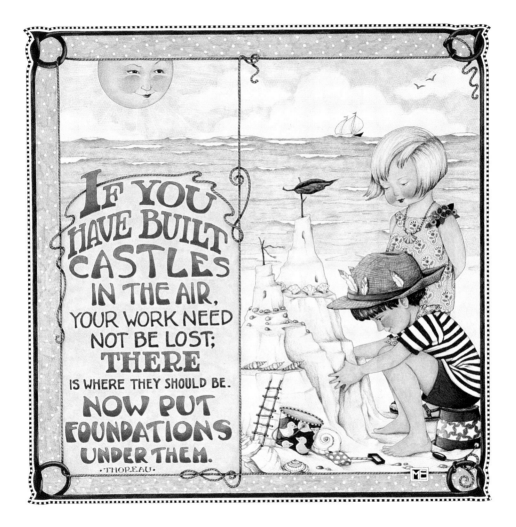

IF YOU HAVE BUILT CASTLES IN THE AIR, YOUR WORK NEED NOT BE LOST; THERE IS WHERE THEY SHOULD BE. NOW PUT FOUNDATIONS UNDER THEM.

· THOREAU ·

52

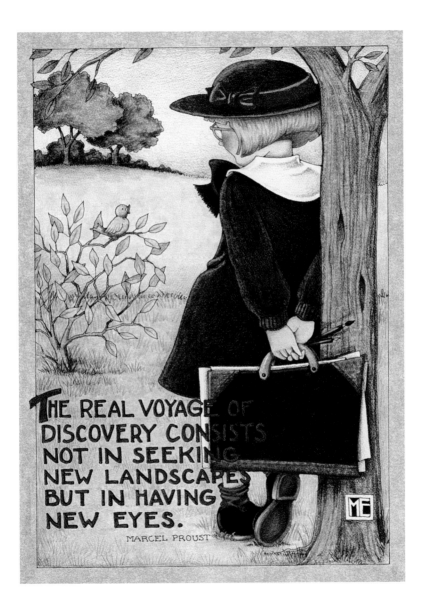

THE REAL VOYAGE OF DISCOVERY CONSISTS NOT IN SEEKING NEW LANDSCAPES BUT IN HAVING NEW EYES.

MARCEL PROUST

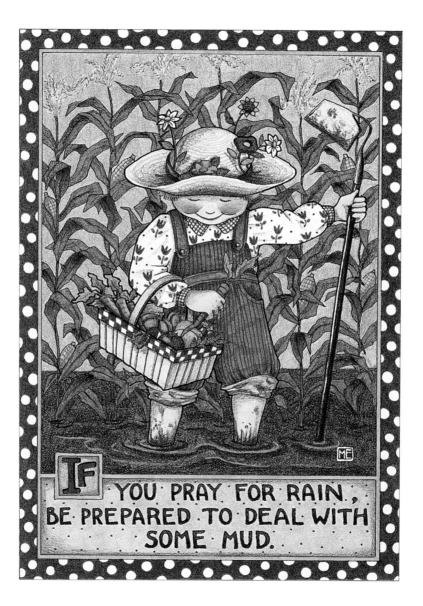

IF YOU PRAY FOR RAIN, BE PREPARED TO DEAL WITH SOME MUD.

54

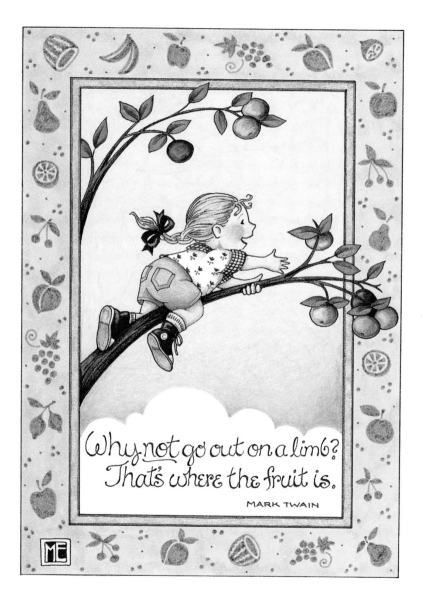

Why not go out on a limb?
That's where the fruit is.

MARK TWAIN

55

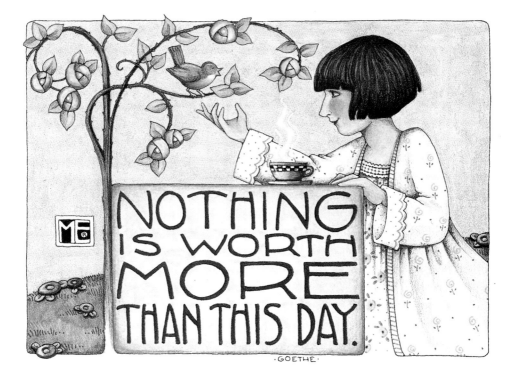

NOTHING IS WORTH MORE THAN THIS DAY.

·GOETHE·

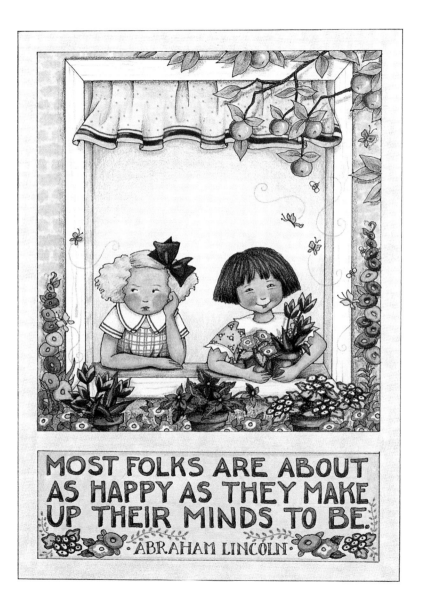

MOST FOLKS ARE ABOUT
AS HAPPY AS THEY MAKE
UP THEIR MINDS TO BE.
·ABRAHAM LINCOLN·

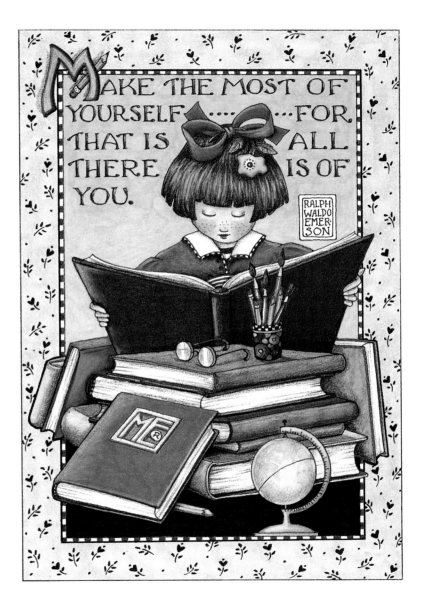

MAKE THE MOST OF YOURSELF ····· FOR THAT IS ALL THERE IS OF YOU.

RALPH WALDO EMERSON

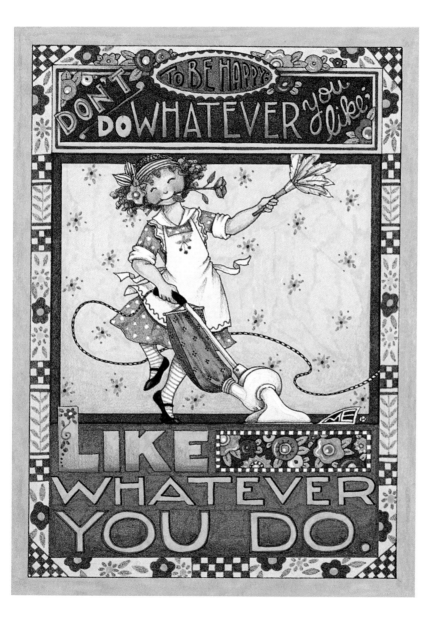

DON'T, TO BE HAPPY, DO WHATEVER you like;
LIKE WHATEVER YOU DO.

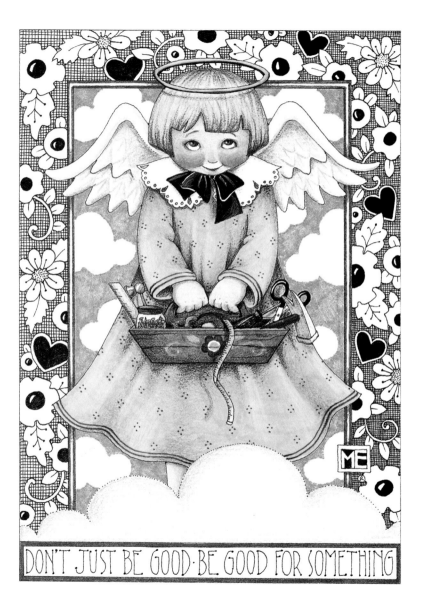

DON'T JUST BE GOOD·BE GOOD FOR SOMETHING

60

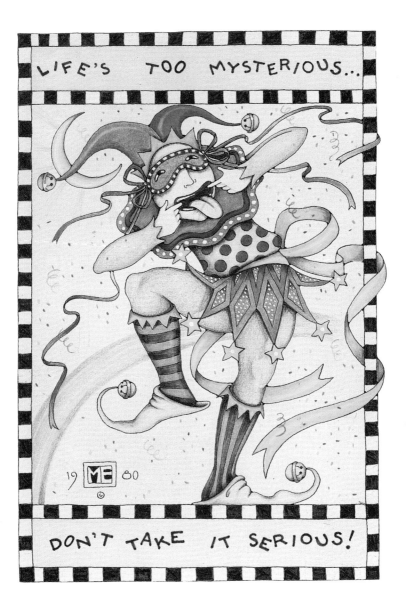

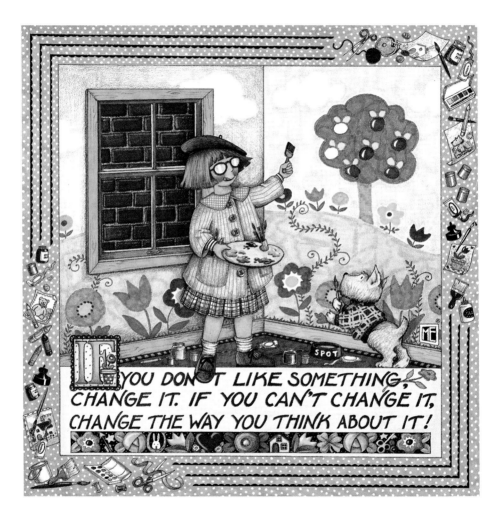

IF YOU DON'T LIKE SOMETHING, CHANGE IT. IF YOU CAN'T CHANGE IT, CHANGE THE WAY YOU THINK ABOUT IT!

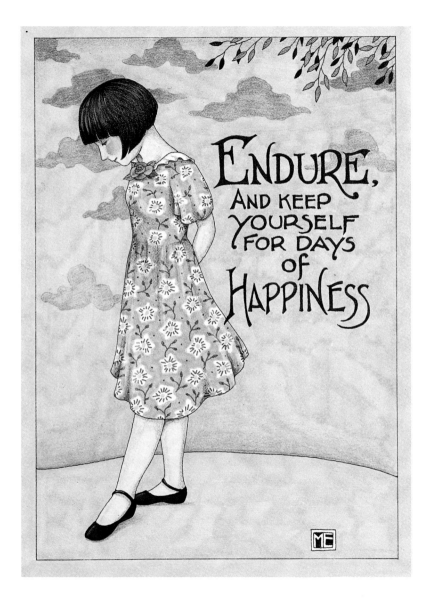

ENDURE, AND KEEP YOURSELF FOR DAYS OF HAPPINESS

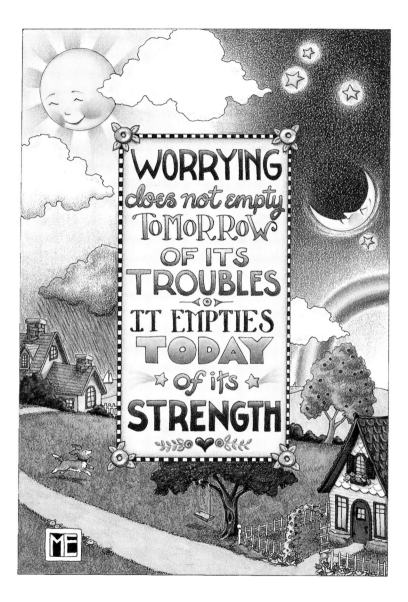

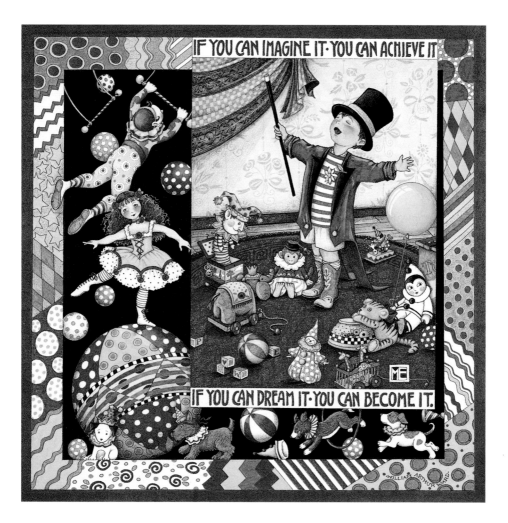

IF YOU CAN IMAGINE IT · YOU CAN ACHIEVE IT

IF YOU CAN DREAM IT · YOU CAN BECOME IT.

·WILLIAM·ARTHUR·WARD·

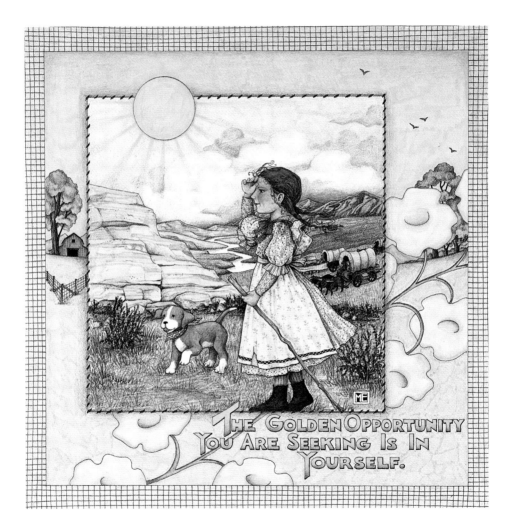

THE GOLDEN OPPORTUNITY YOU ARE SEEKING IS IN YOURSELF.

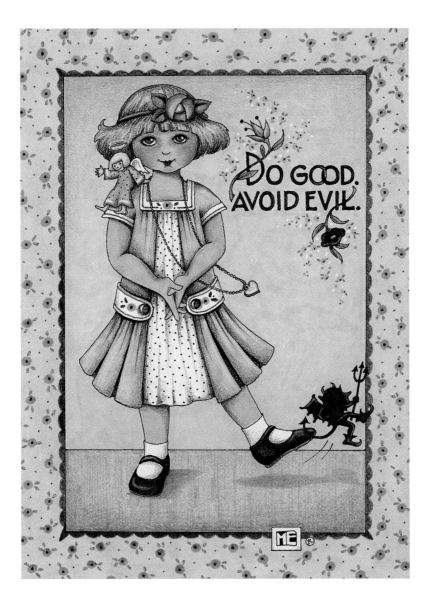

67

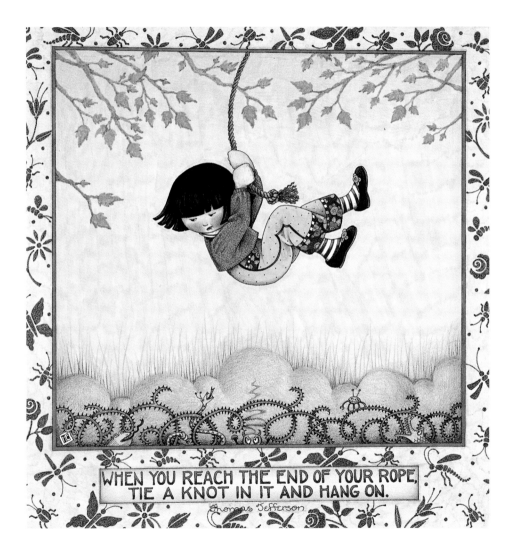

WHEN YOU REACH THE END OF YOUR ROPE,
TIE A KNOT IN IT AND HANG ON.

Thomas Jefferson

68

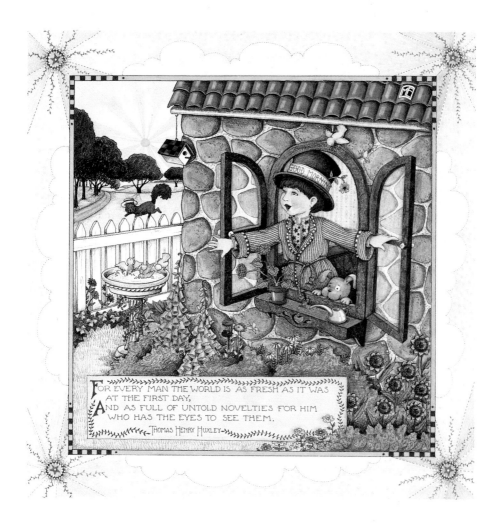

FOR EVERY MAN THE WORLD IS AS FRESH AS IT WAS
AT THE FIRST DAY,
AND AS FULL OF UNTOLD NOVELTIES FOR HIM
WHO HAS THE EYES TO SEE THEM.
—THOMAS HENRY HUXLEY—

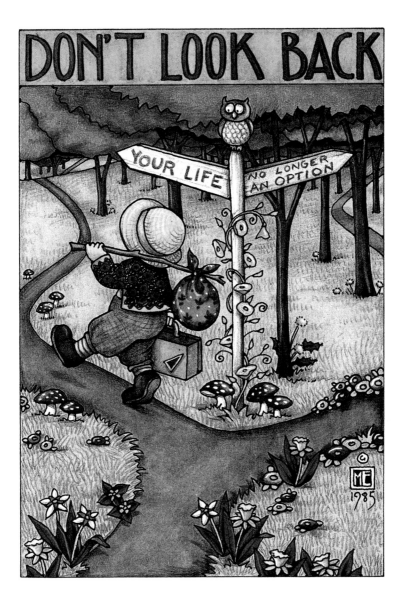

70

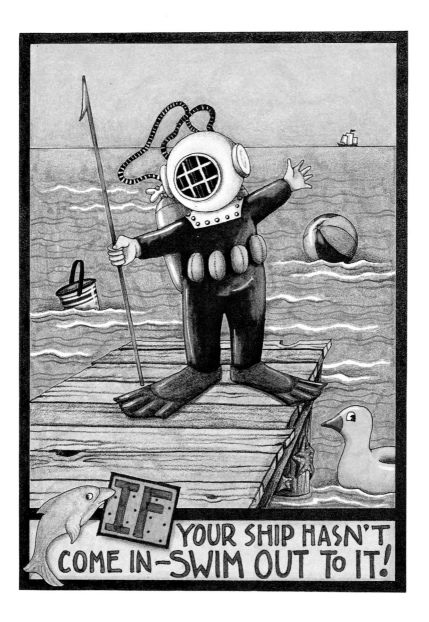

IF YOUR SHIP HASN'T COME IN—SWIM OUT TO IT!

chapter 3

Life Isn't Always a Bowl of Cherries

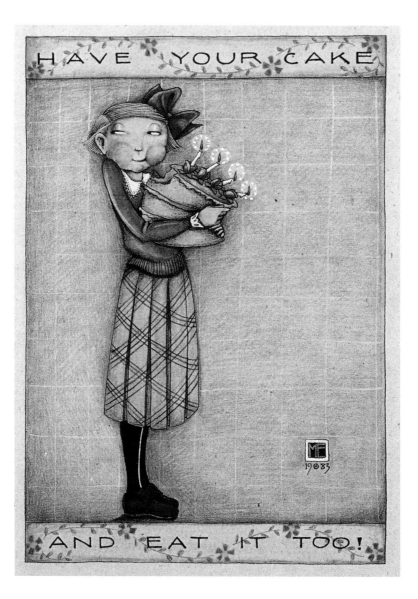

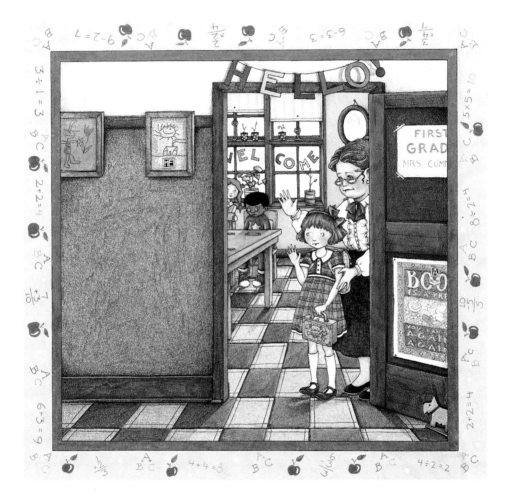

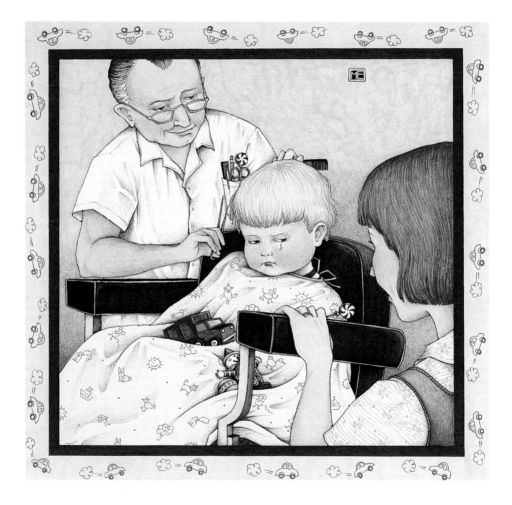

77

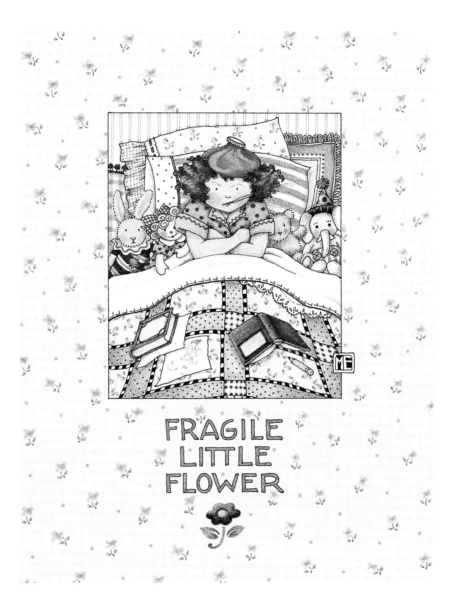

FRAGILE
LITTLE
FLOWER

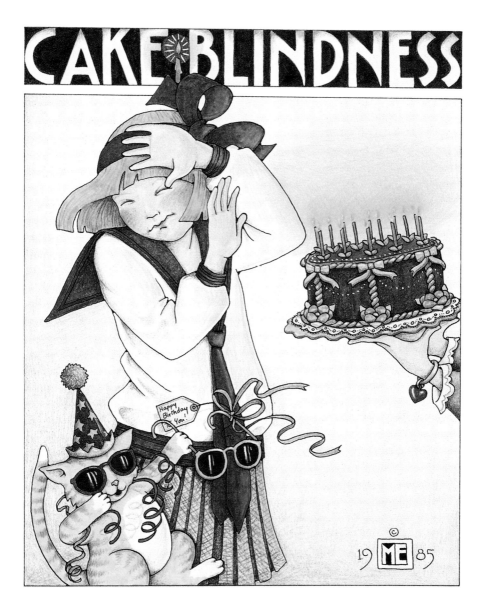

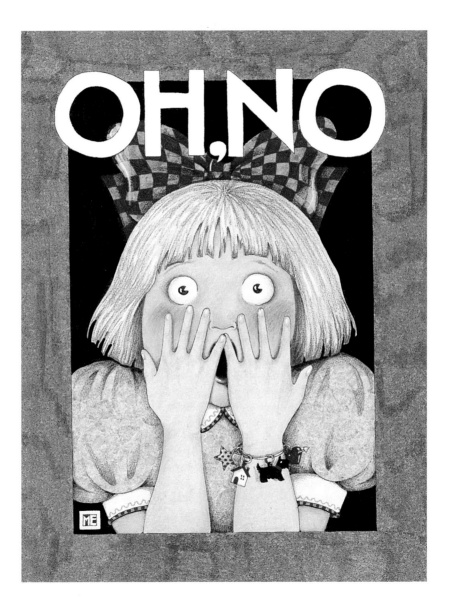

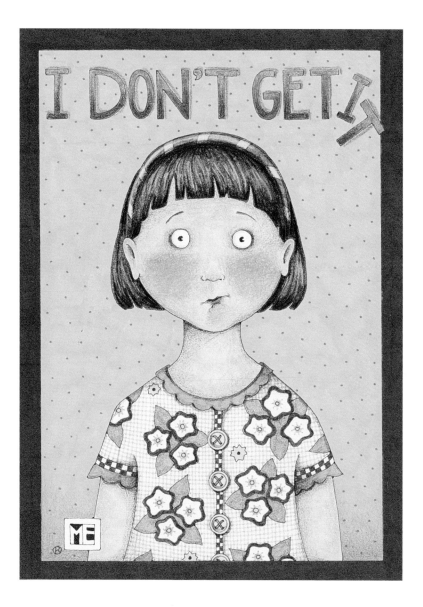

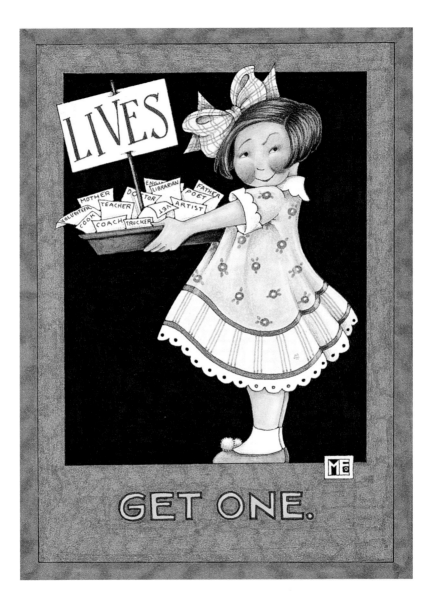

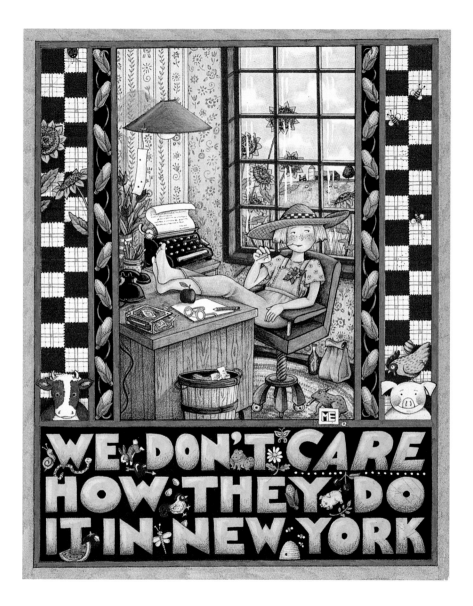

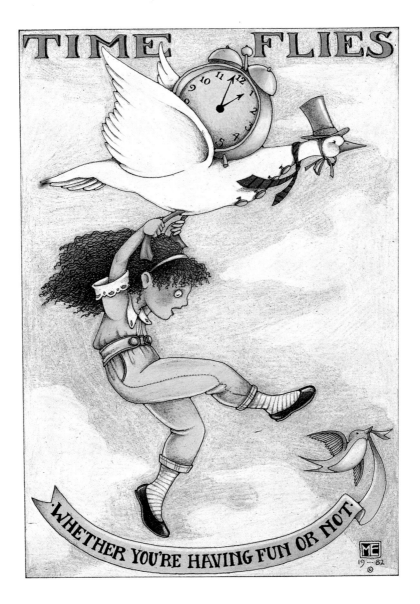

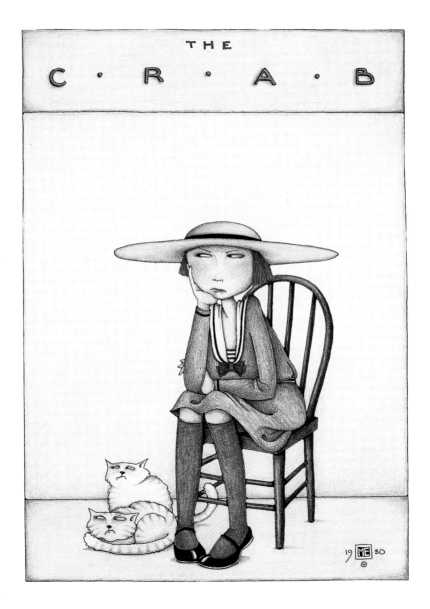

THE

C · R · A · B

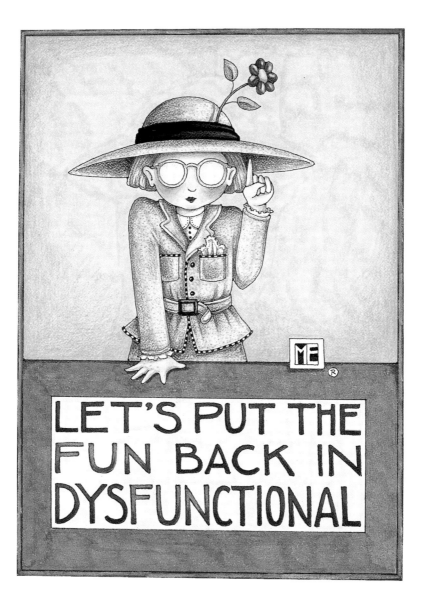

LET'S PUT THE FUN BACK IN DYSFUNCTIONAL

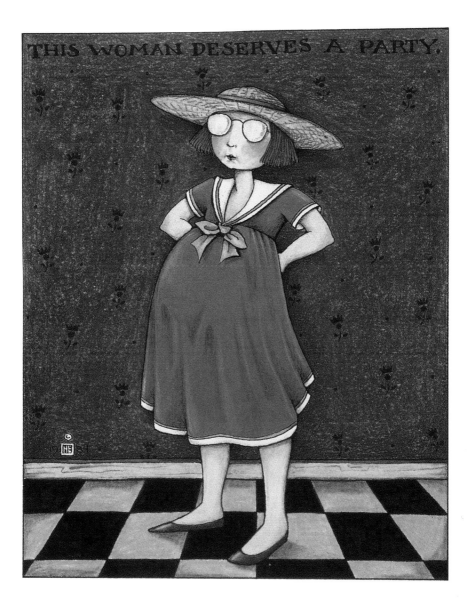

87

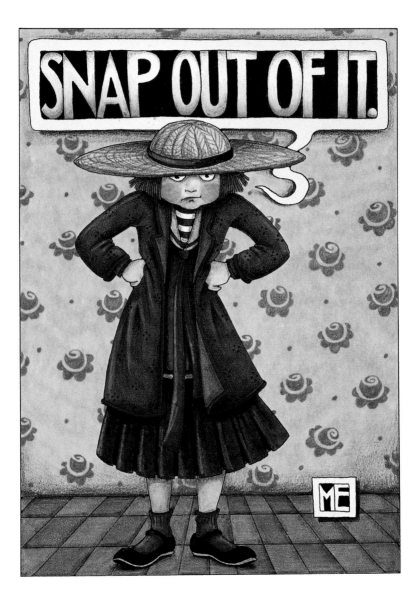

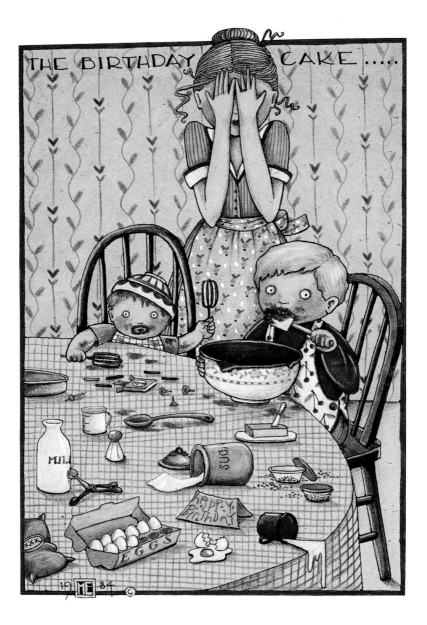

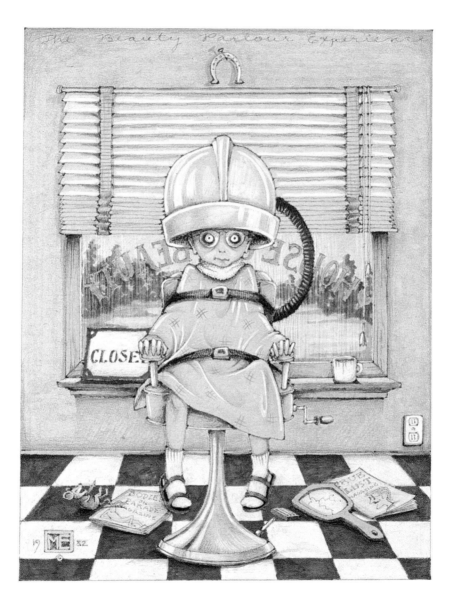

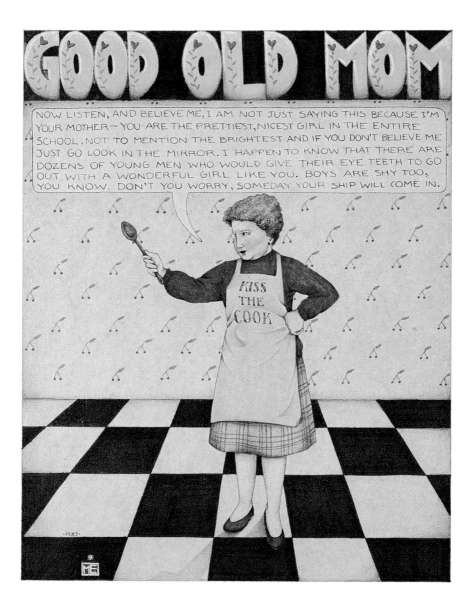

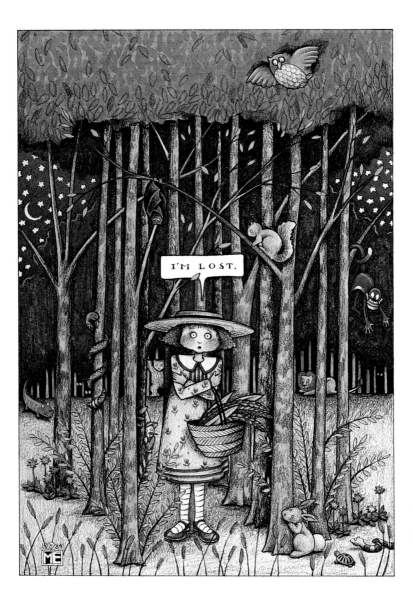

92

QUEENS NEVER MAKE BARGAINS.

······— LEWIS CARROLL ·····

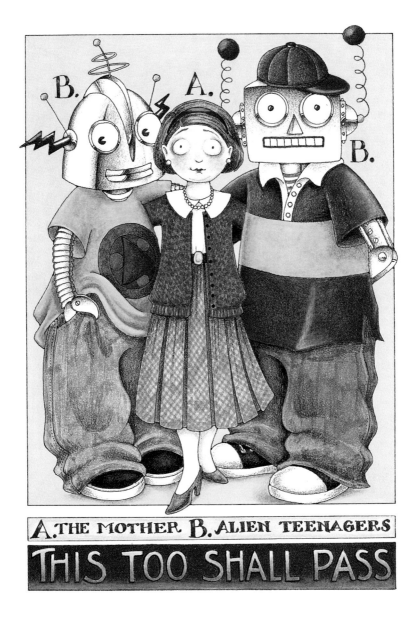

A. THE MOTHER B. ALIEN TEENAGERS

THIS TOO SHALL PASS

94

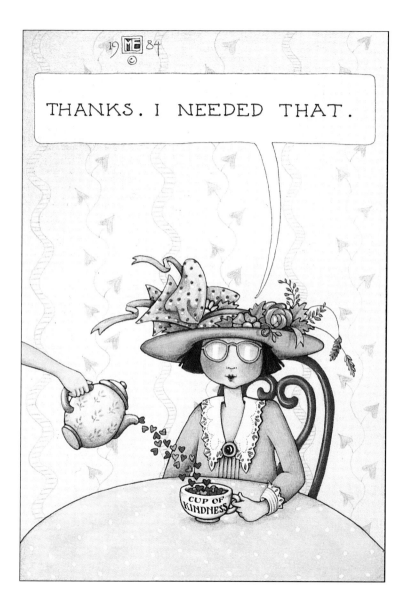

chapter 4
The Child in ME

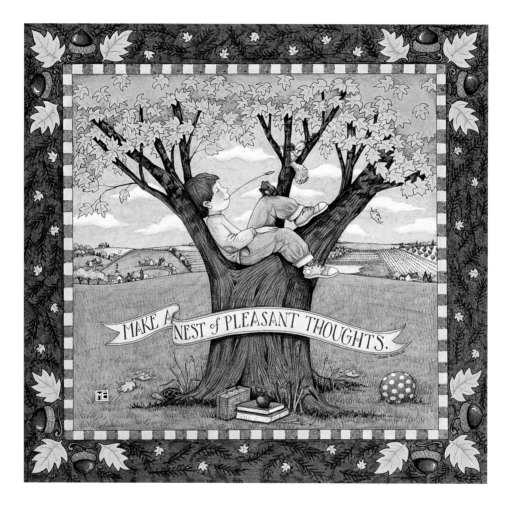

MAKE A NEST of PLEASANT THOUGHTS.

JOHN RUSKIN

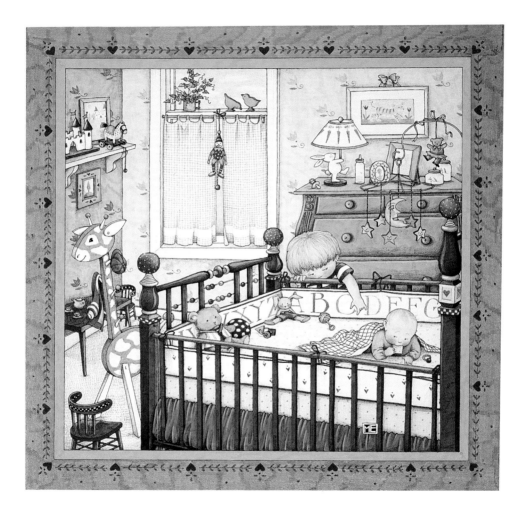

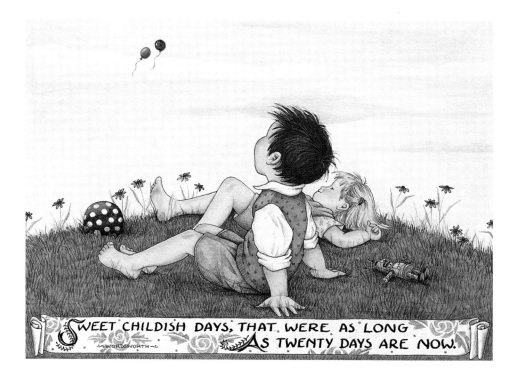

SWEET CHILDISH DAYS, THAT WERE AS LONG
~ WORDSWORTH ~ AS TWENTY DAYS ARE NOW.

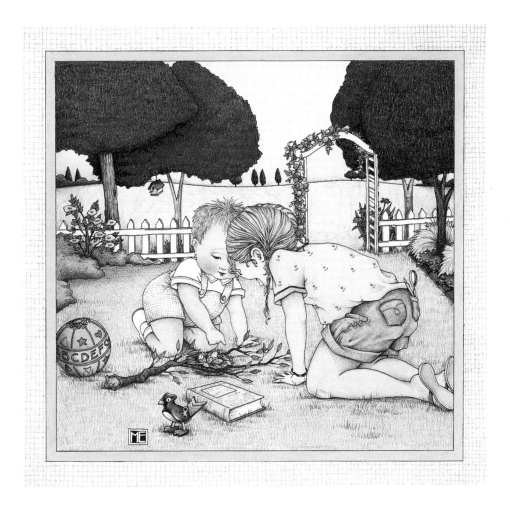

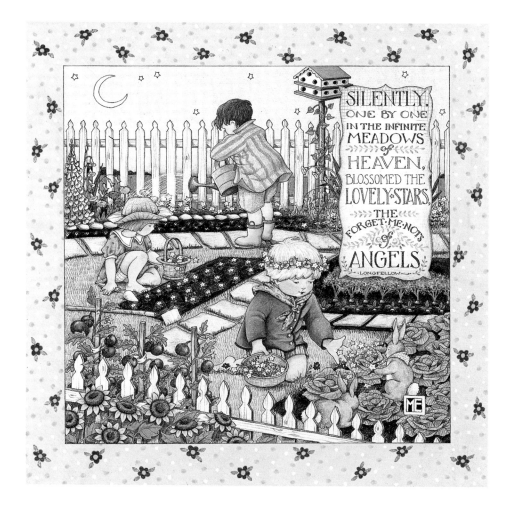

SILENTLY,
ONE BY ONE
IN THE INFINITE
MEADOWS
of
HEAVEN,
BLOSSOMED THE
LOVELY·STARS,
THE
FORGET·ME·NOTS
of
ANGELS

·LONGFELLOW·

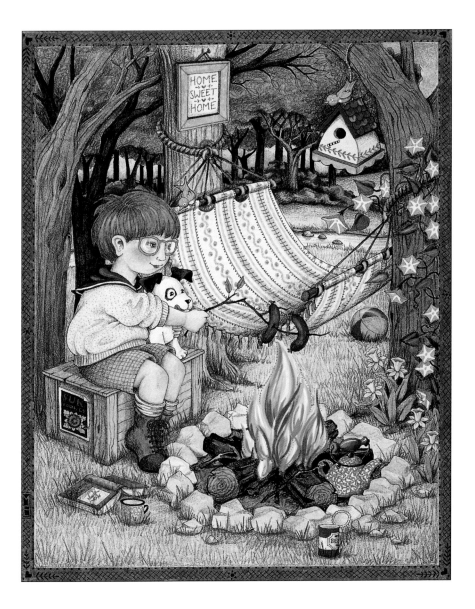

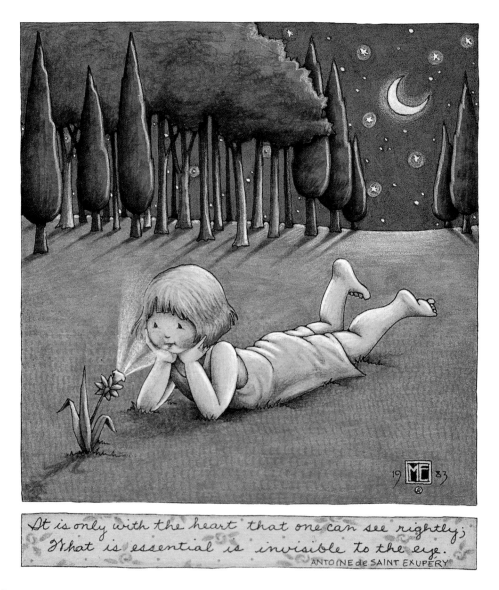

It is only with the heart that one can see rightly;
What is essential is invisible to the eye.

ANTOINE de SAINT EXUPERY

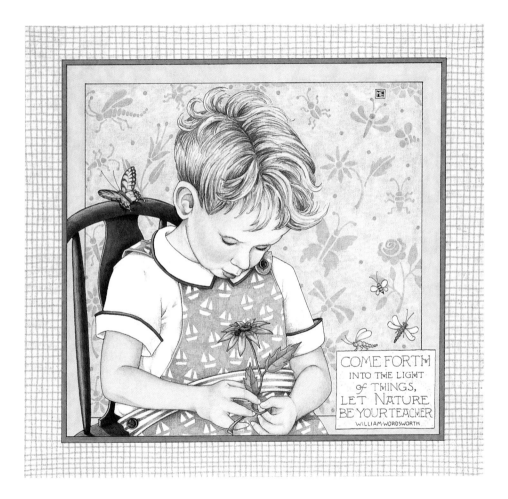

COME FORTH
INTO THE LIGHT
of THINGS,
LET NATURE
BE YOUR TEACHER
WILLIAM WORDSWORTH

105

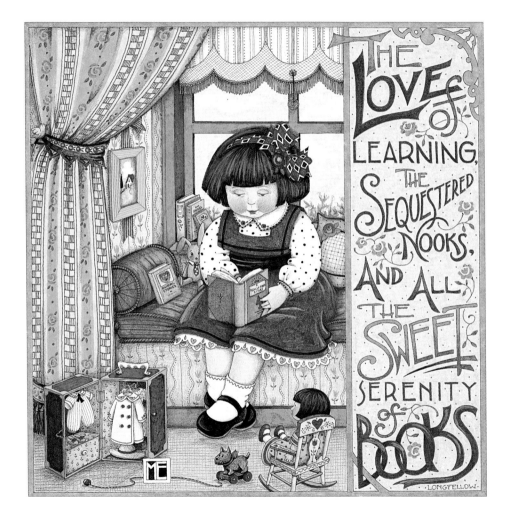

THE LOVE OF LEARNING, THE SEQUESTERED NOOKS, AND ALL THE SWEET SERENITY OF BOOKS

LONGFELLOW

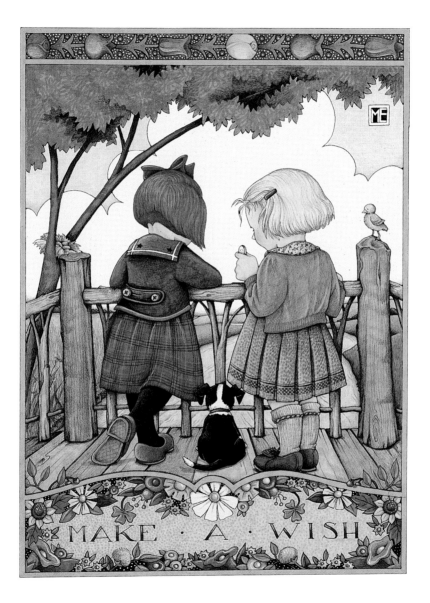

MAKE · A · WISH

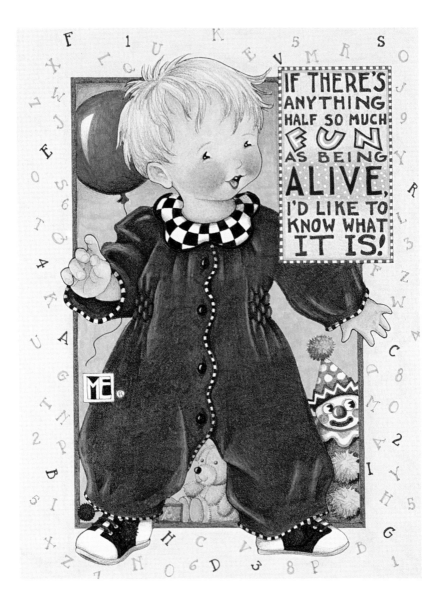

IF THERE'S ANYTHING HALF SO MUCH **FUN** AS BEING **ALIVE,** I'D LIKE TO KNOW WHAT **IT IS!**

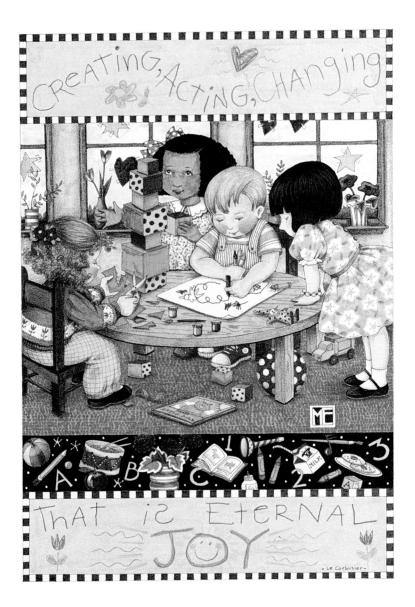

CREATING, ACTING, CHANGING

THAT IS ETERNAL JOY

• Le Corbusier •

109

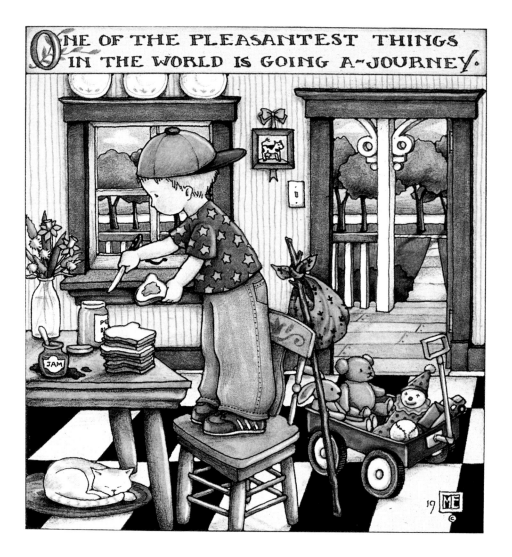

ONE OF THE PLEASANTEST THINGS IN THE WORLD IS GOING A-JOURNEY.

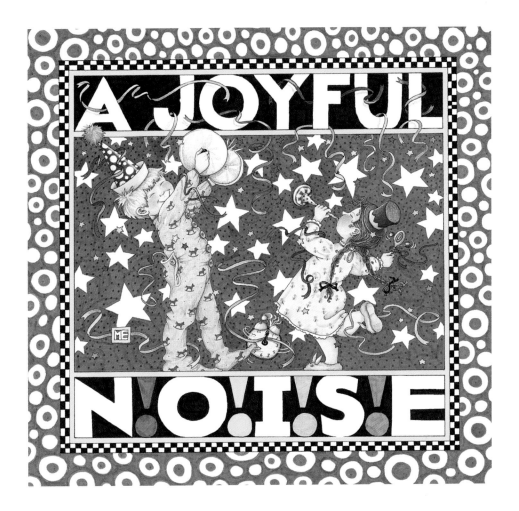

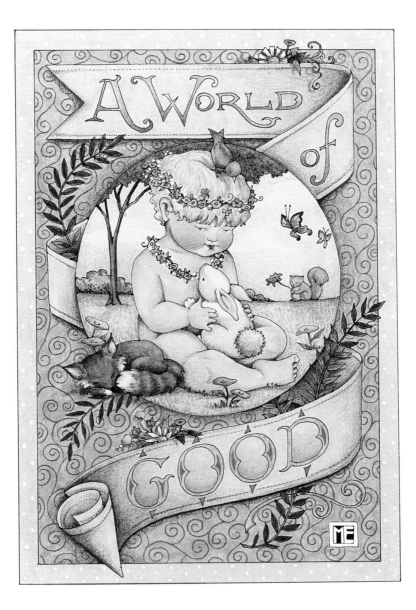

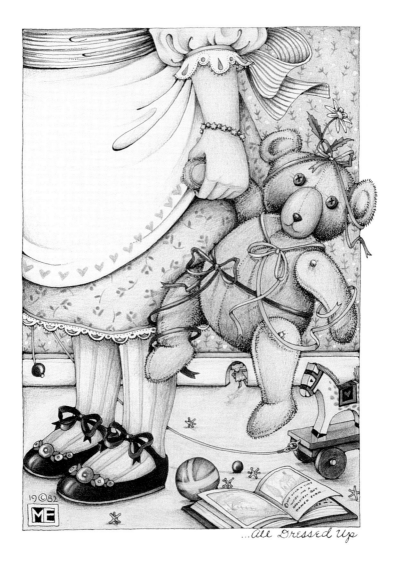

...All Dressed Up

113

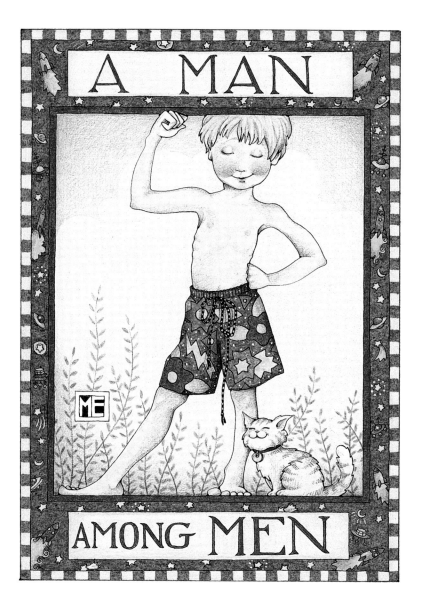

A MAN

AMONG MEN

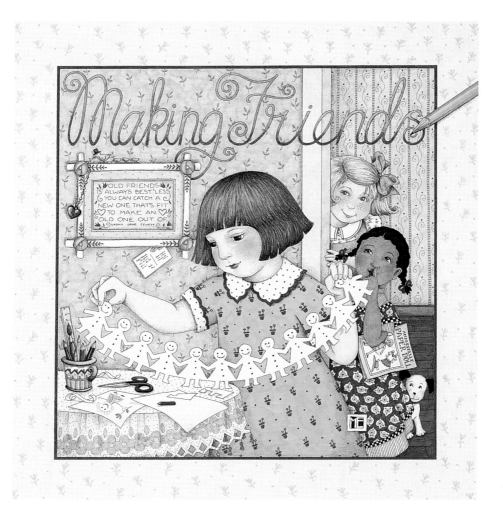

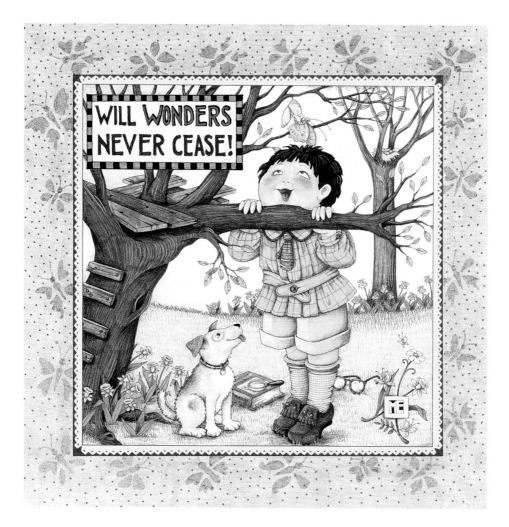

116

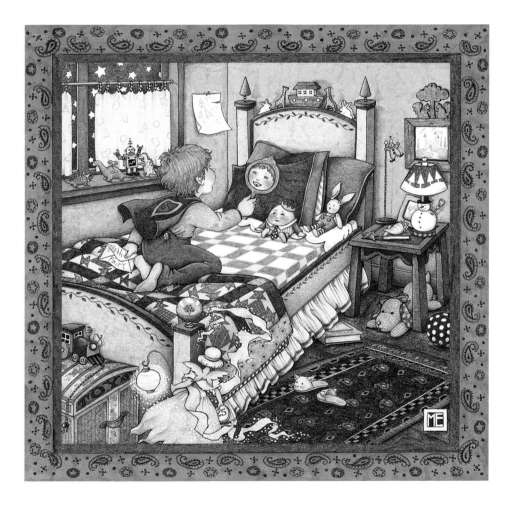

117

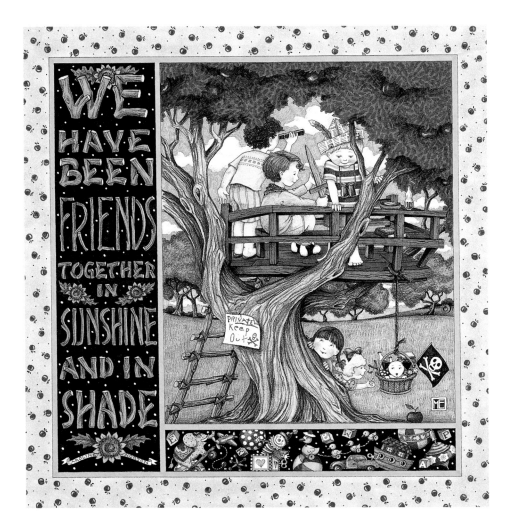

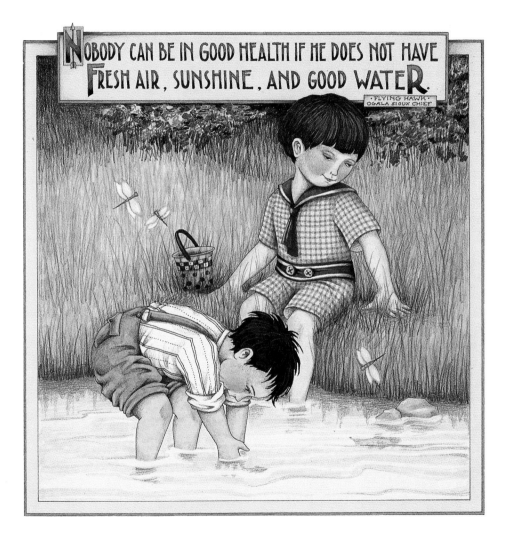

NOBODY CAN BE IN GOOD HEALTH IF HE DOES NOT HAVE FRESH AIR, SUNSHINE, AND GOOD WATER.

· FLYING HAWK ·
OGALA SIOUX CHIEF

119

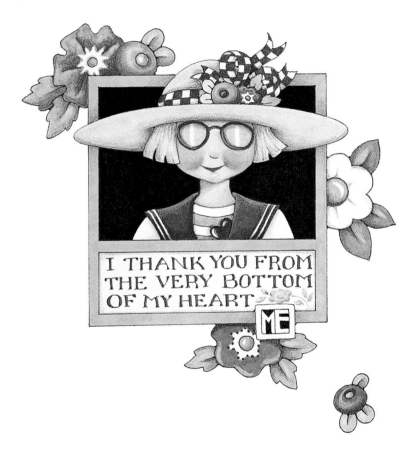

I THANK YOU FROM THE VERY BOTTOM OF MY HEART